THE COLORING BOOK OF
PUEBLO POTTERY

BRIAN VALLO

LINE DRAWINGS
PAULA KINSEL

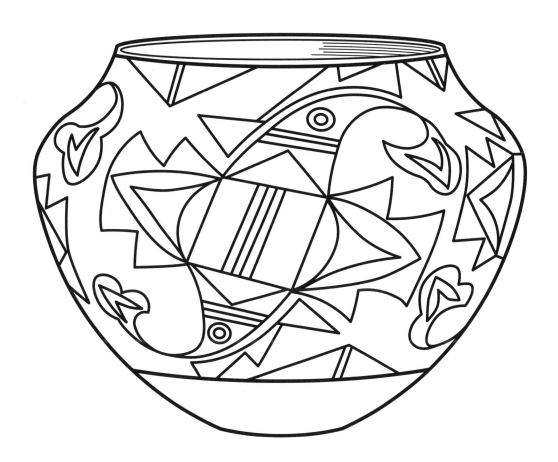

MERRELL

LONDON · NEW YORK

IN ASSOCIATION WITH

VILCEK
FOUNDATION

INTRODUCTION

Do you know the location of the oldest city in North America? Are you familiar with the Indigenous people, also referred to as Native Americans, who live throughout the United States? And what does the term *Pueblo* mean to you? Many Americans are unfamiliar with the first Americans and their enduring culture, history, homelands, artistry, and contributions to the development of the United States. You may have watched a movie or television program in which Native Americans are depicted in a stereotypical way, wearing a warbonnet, riding a horse, and living in a tepee. The reality is that the cultures of the 574 Native American tribes in the United States are diverse, and each has its own language and way of life that are centuries old.

The lands of the nineteen Pueblo tribes of New Mexico and of the Hopi Tribe of Arizona are some of the oldest settlements in North America. The Pueblos of Acoma and Taos and the Hopi Tribe reservation contend for the designation of the oldest continuously inhabited settlement in the United States. The term *Pueblo* is a Spanish word meaning "town" or "village." When the Spanish arrived in 1540 in what is now known as the Southwest, they came upon the ancient Indigenous tribes. They referred to them as Pueblos and

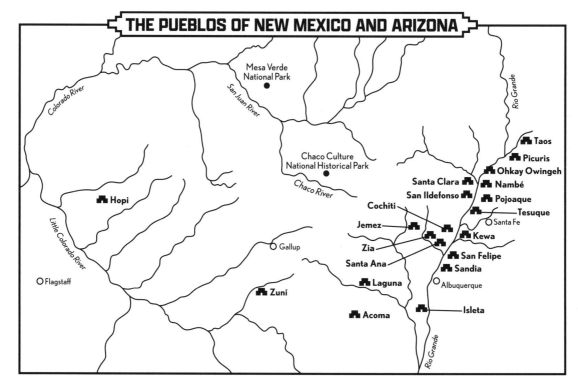

formalized this reference with the establishment of Catholic missions in each of the tribal communities. Later, the United States government adopted the names of the Pueblo tribes, and most have retained these names. Only recently have some Pueblos returned to their indigenous name: Kewa Pueblo was formerly known as Santo Domingo, and Ohkay Owingeh was previously the Pueblo of San Juan. Now you can confidently answer the three questions posed above!

The origin of the Pueblo people dates back further in time. The Ancestral Puebloans built magnificent stone great houses throughout the Southwest at places including Mesa Verde in southwestern Colorado and Chaco Canyon in north-central New Mexico. The pottery-making tradition is as old as the ancient Pueblos themselves. Various forms of pottery are made for cooking, gathering water, food storage, and ceremonial use. Pottery is used throughout the life of a Pueblo person, from birth to death. Since the time of the Ancestral Puebloans, pottery has been made predominantly by women. The pots are created from natural clay using a coil method; they are hand-painted and then fired outdoors. Designs vary from one Pueblo to another, but many symbols and motifs are shared by the Pueblos. Contemporary Pueblo pottery features both ancient designs and modified versions of symbols and motifs.

In this coloring book are examples of Pueblo pottery from the collection of the Vilcek Foundation made mostly in the late nineteenth and early twentieth centuries. Many pots in this collection left homes in the Pueblos and were either sold or exchanged for basic goods. Today, historic pottery of this type is highly collectible and can be found in museums throughout the world and in private collections. To the Pueblo people, pottery represents the continuance of life. I invite you to enjoy these drawings of the pottery and ask that you think about the people and cultures from which these incredibly beautiful pots originate.

Brian Vallo *Pueblo of Acoma*

Zia water jar
c. 1890
Clay and paint
H. 13 in. (33 cm)
VILCEK COLLECTION
VF2018.02.05

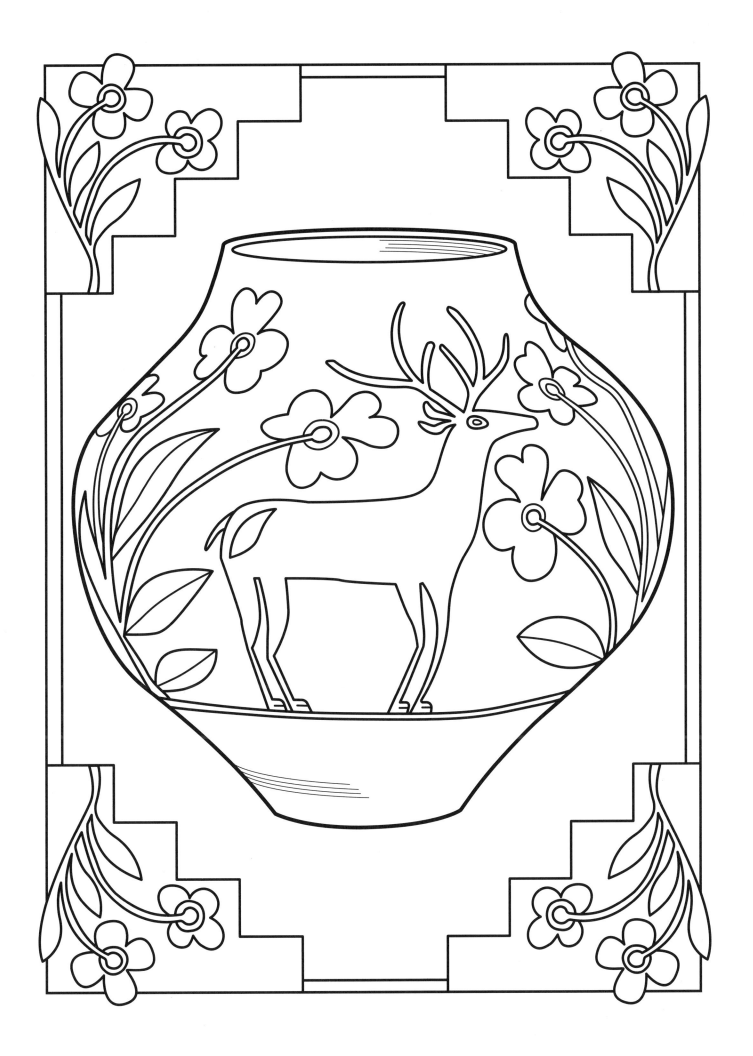

Tesuque storage jar
c. 1870–80
Clay and paint
H. 15½ in. (39.4 cm)
VILCEK COLLECTION
VF2016.01.08

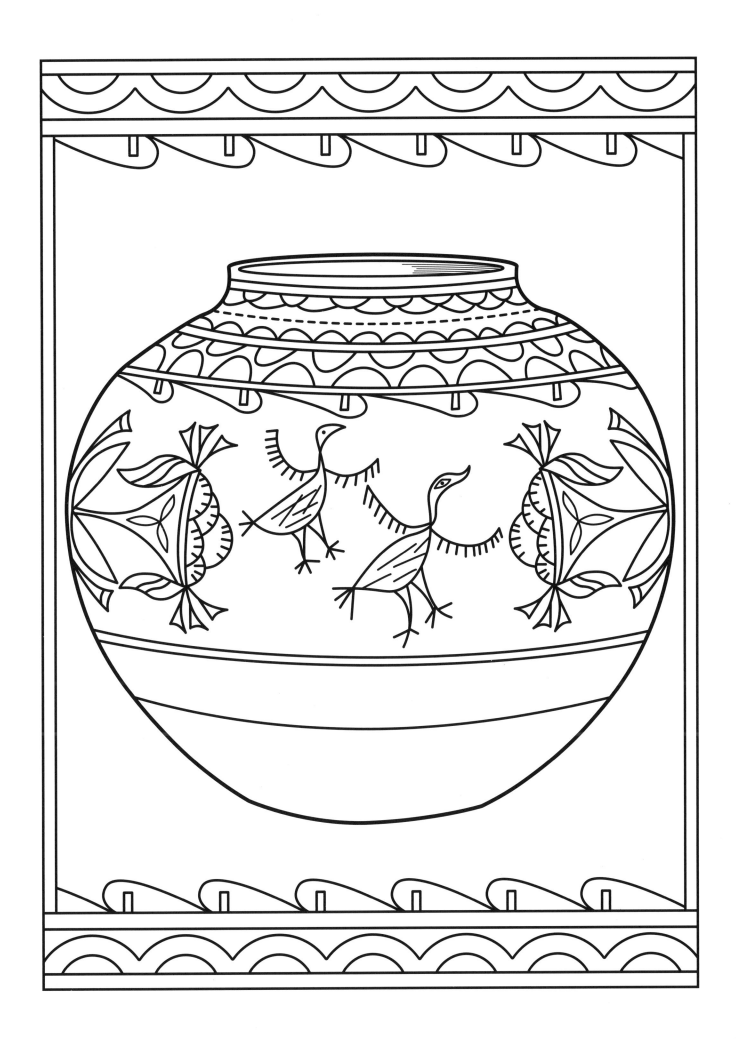

Cochiti storage jar
c. 1870
Clay and paint
H. 18½ in. (47 cm)
VILCEK COLLECTION
2011.10.01

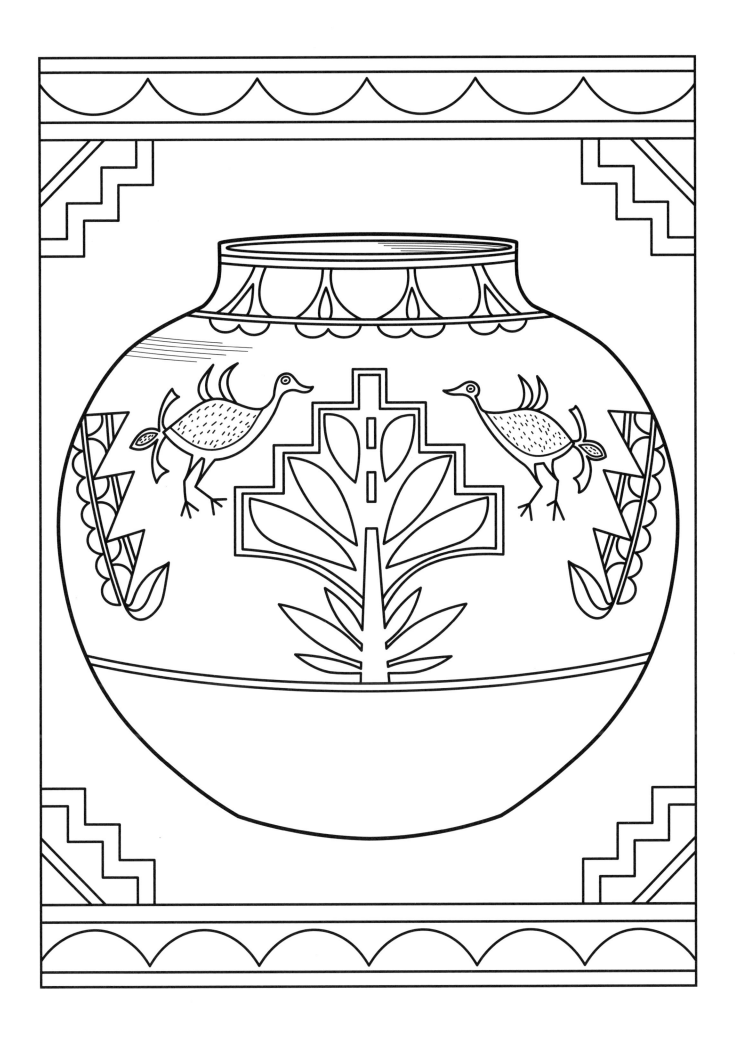

Acoma water jar
c. 1895
Clay and paint
H. 11½ in. (29.2 cm)
VILCEK COLLECTION
VF2014.02.02

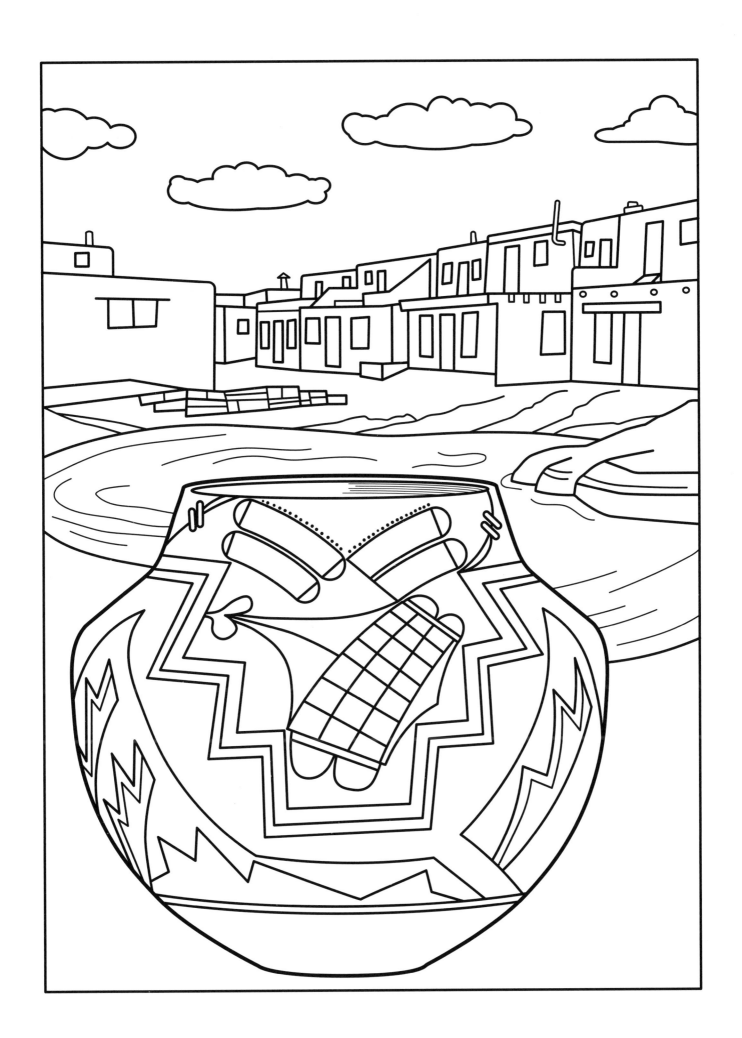

Acoma water jar
c. 1870
Clay and paint
H. 14 in. (35.6 cm)
VILCEK COLLECTION
VF2019.02.10

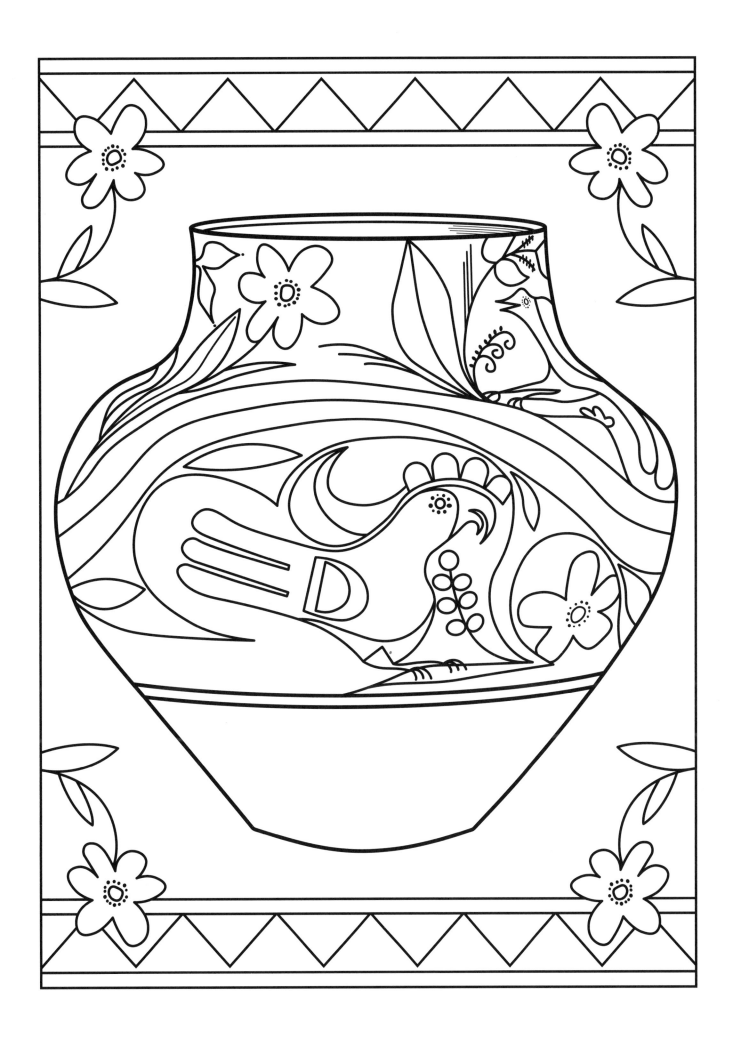

Acoma water jar
20th century
Clay and paint
H. 6¾ in. (17.2 cm)
VILCEK COLLECTION
VF2019.02.02

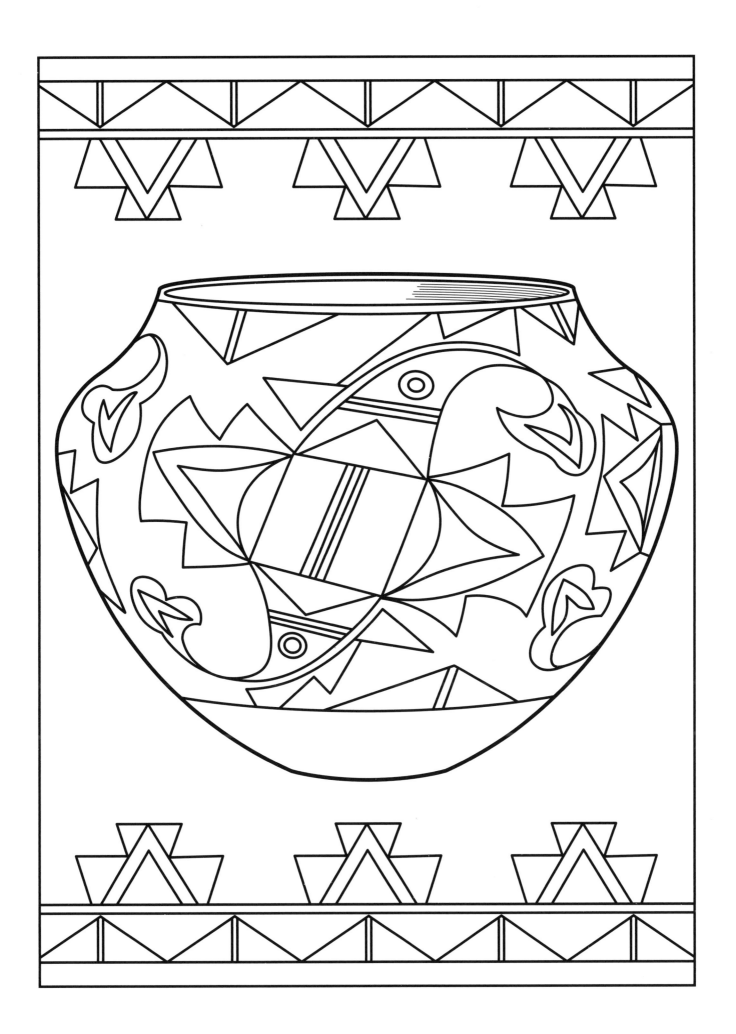

A Pueblo woman is
greeted by her pet dog
on her return from
gathering water
at the river.

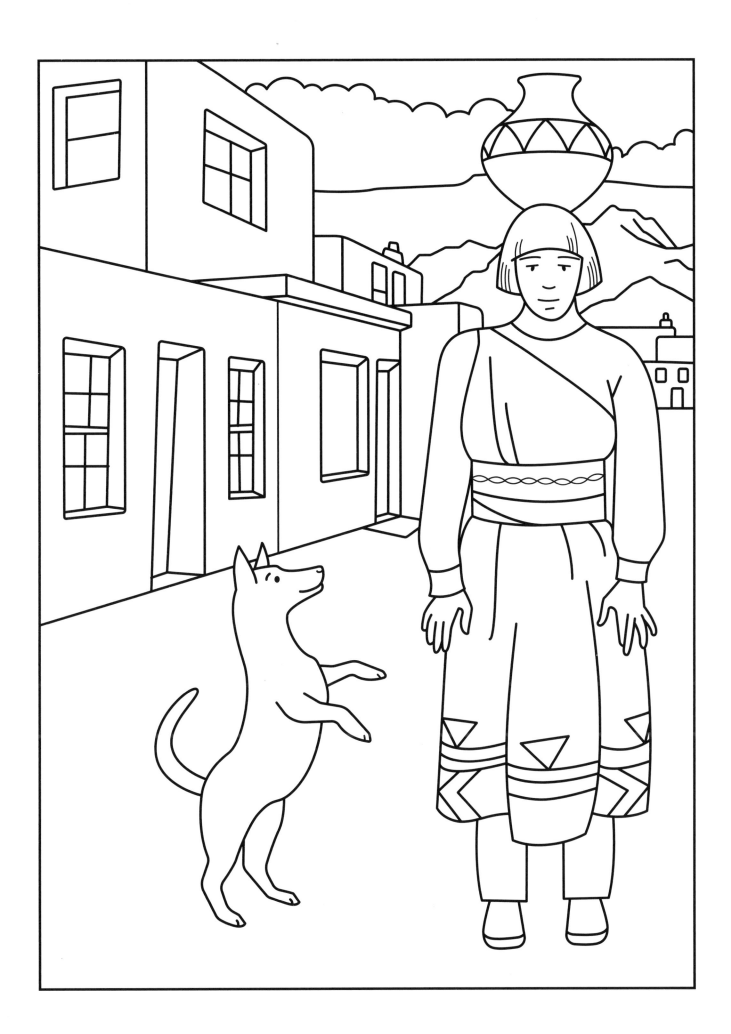

Reyes Galvan
(1860/61-1934)
Zia storage jar
c. 1895
Clay and paint
H. 17¾ in. (45.1 cm)

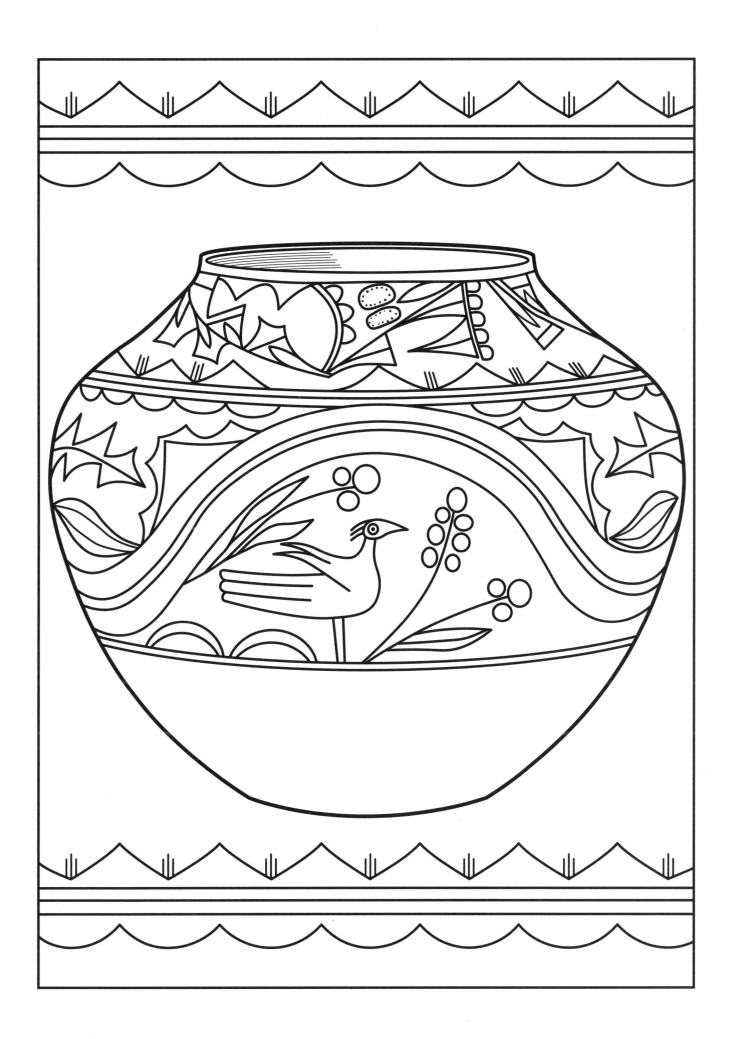

Zia water jar
c. 1810
Clay and paint
H. 9½ in. (24.1 cm)

Monica Silva
Kewa dough bowl
c. 1920-40
Clay and paint
H. 8½ in. (21.6 cm)

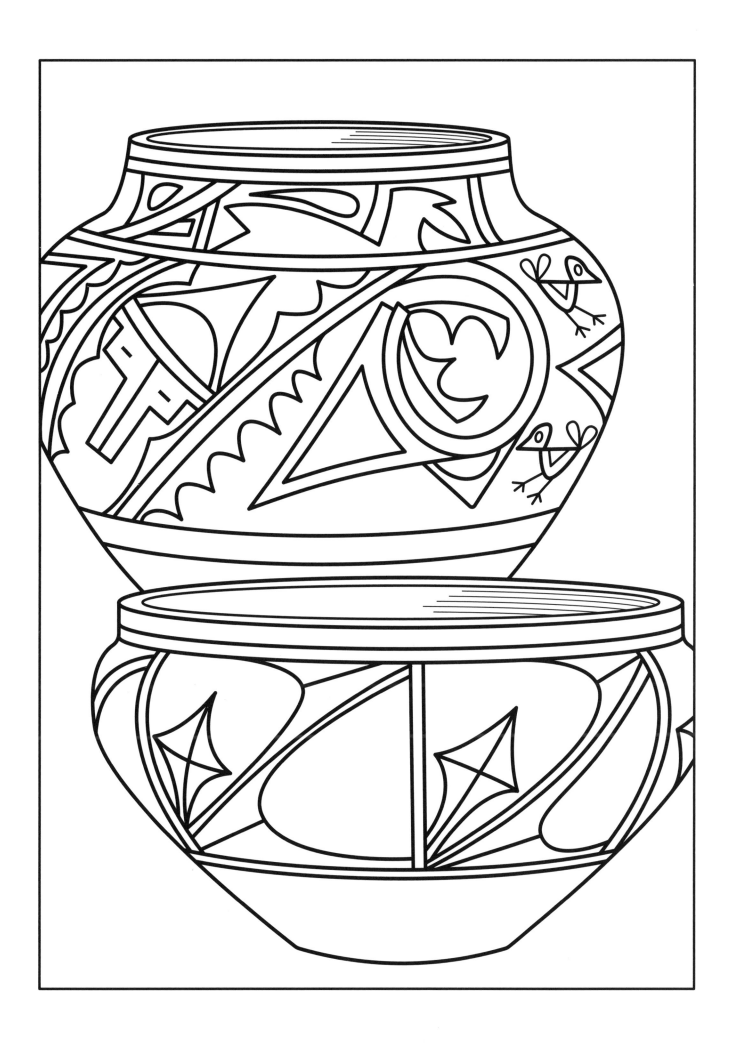

Zia water jar
c. 1880
Clay and paint
H. 10 in. (25.4 cm)

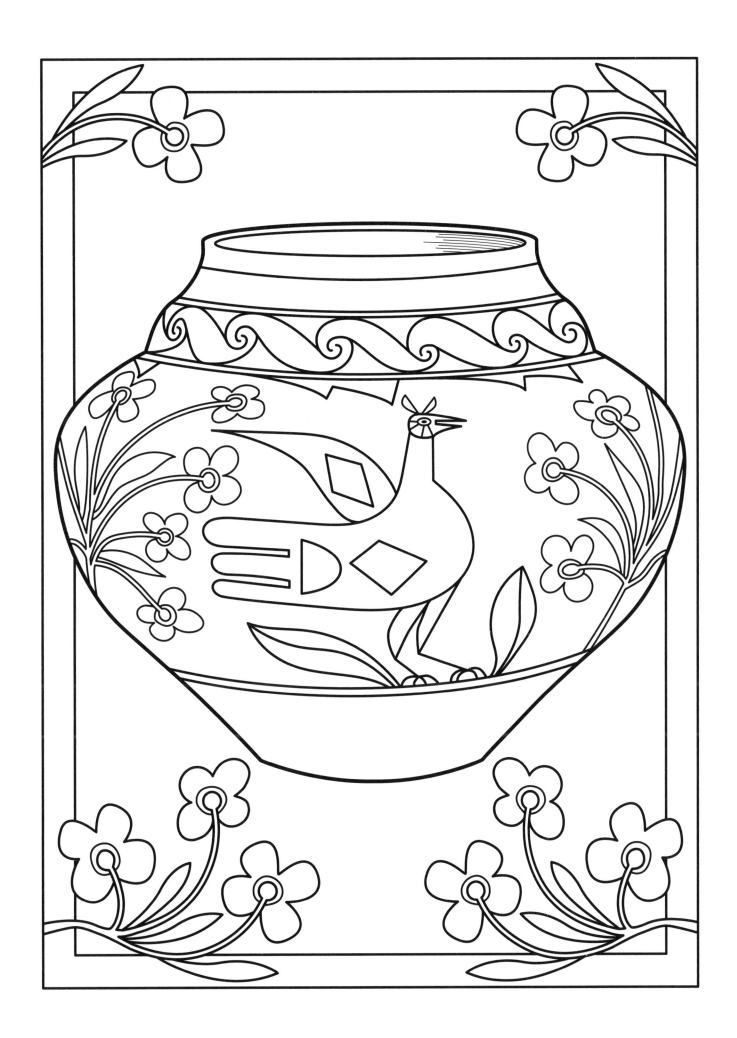

Acoma water jar
c. 1920–30
Clay and paint
H. 10¼ in. (26 cm)

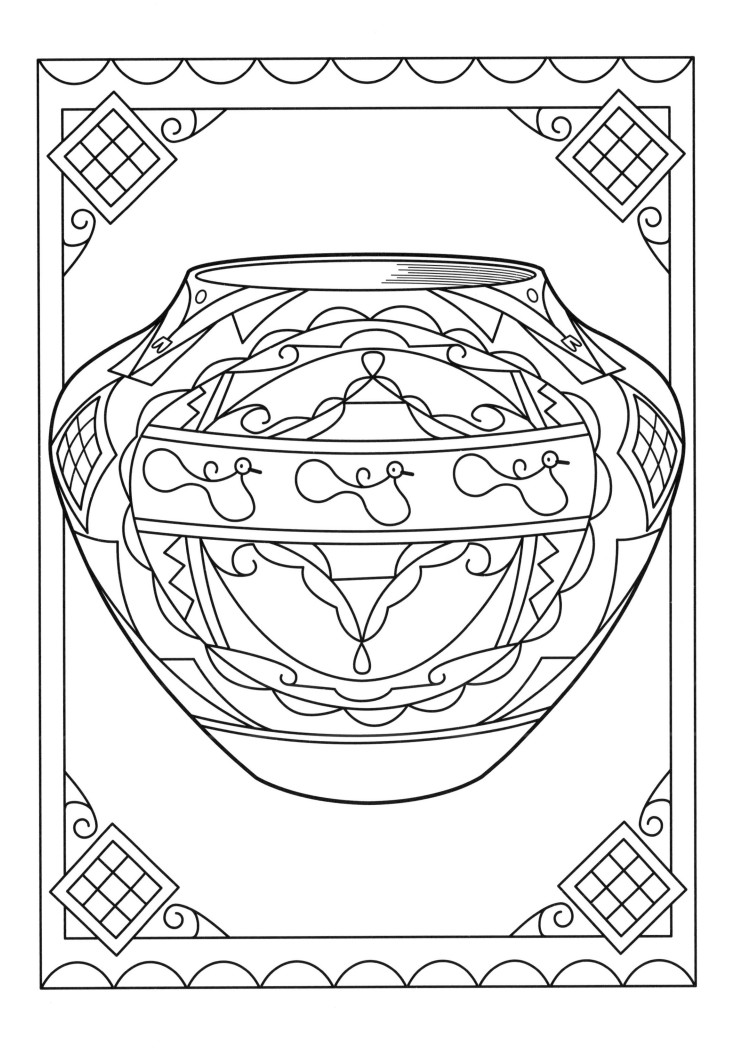

Zia/Santa Ana
storage jar
c. 1885
Clay and paint
H. 17 in. (43.2 cm)

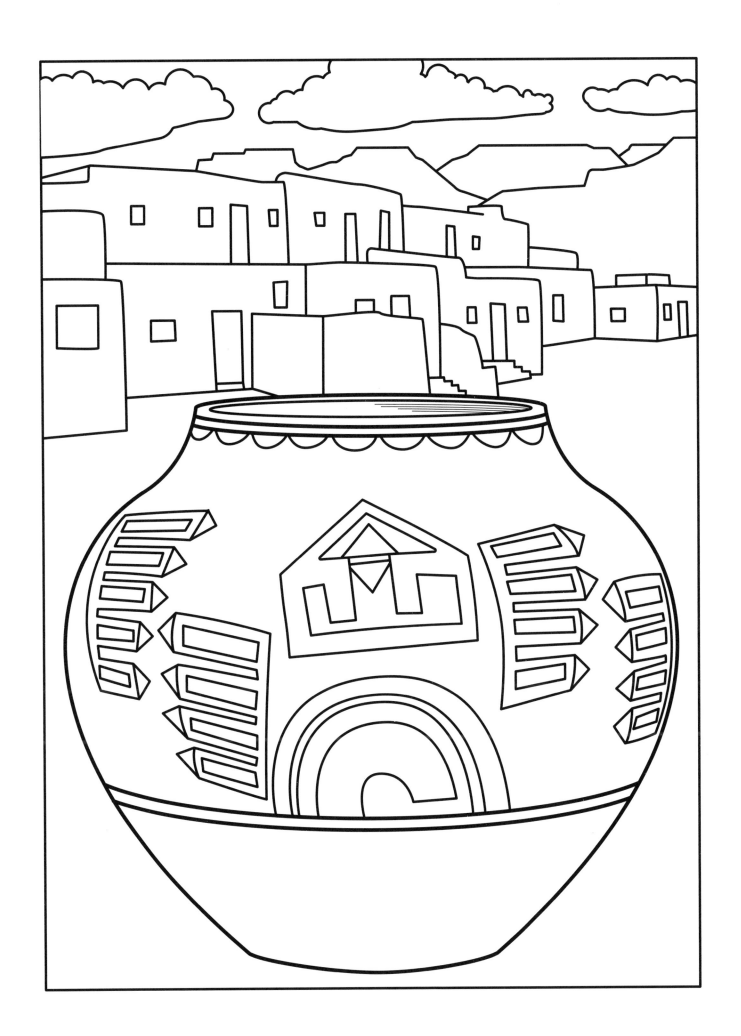

Tesuque water jar
1860–1920
Clay and paint
H. 9 in. (22.9 cm)
VILCEK COLLECTION
VF2016.01.09

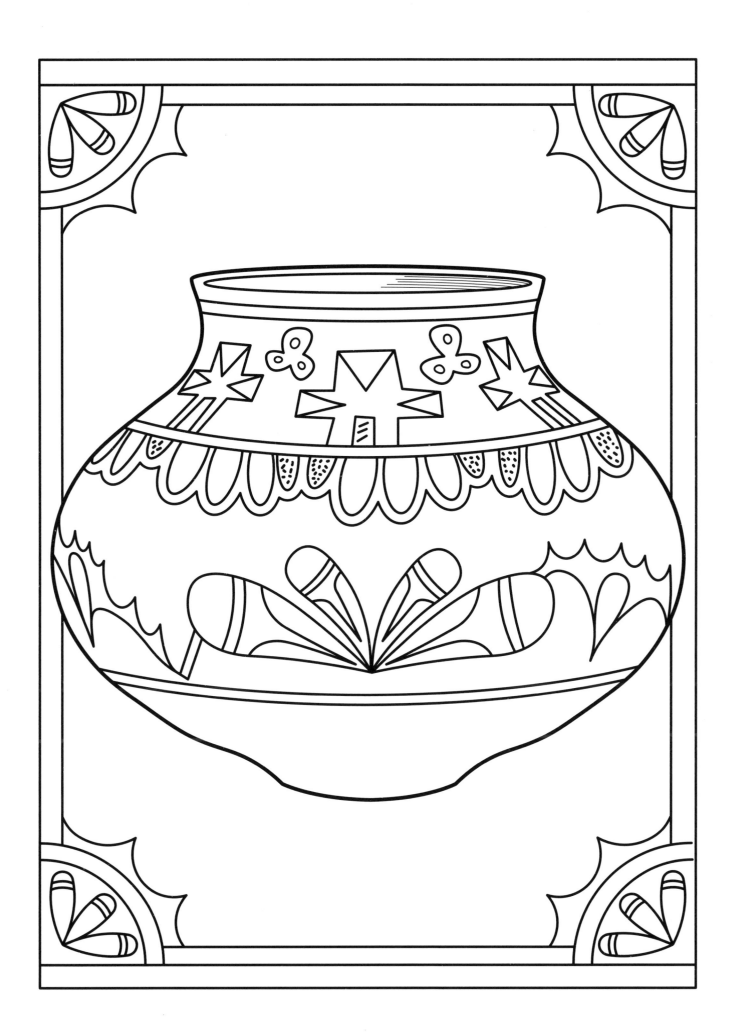

**Ancestral
Pueblo storage jar**
1100-1300 CE
Clay and paint
H. 8¼ in. (21 cm)

VILCEK COLLECTION
VF2010.01.01

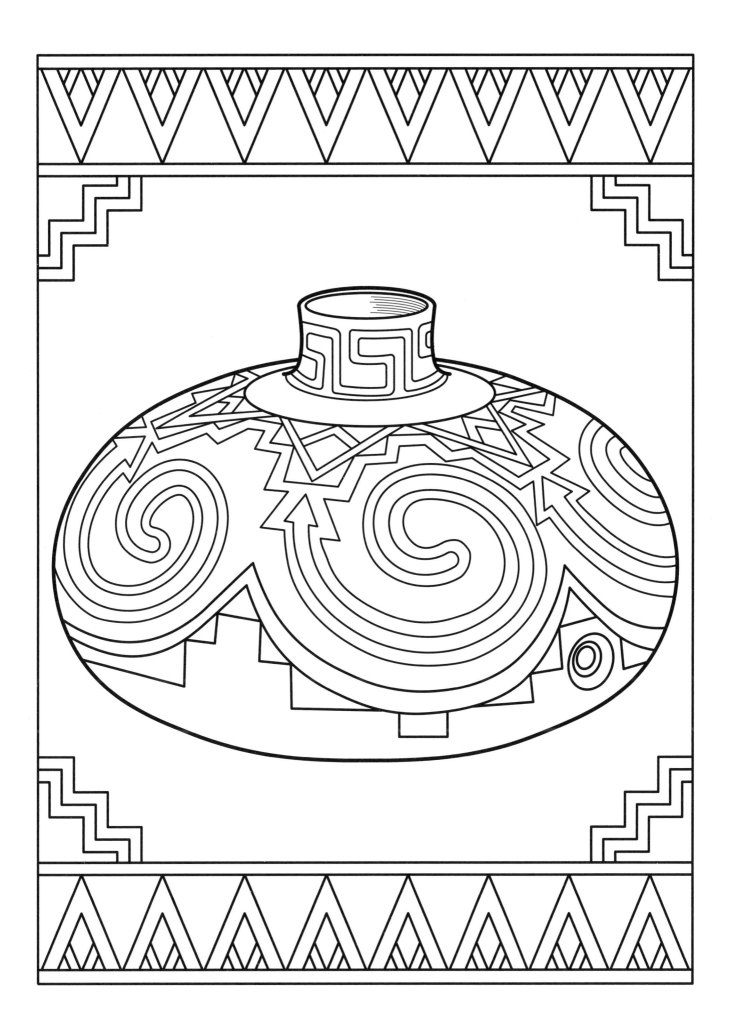

**Powhoge
storage jar**
c. 1820s
Clay and paint
H. 16 in. (40.6 cm)
VILCEK COLLECTION
VF2018.02.03

Marianita Roybal
(1843–*c.* 1910)
**San Ildefonso
lidded jar**
c. 1880-90
Clay and paint
H. 12½ in. (31.8 cm)
VILCEK COLLECTION
VF2016.01.04

**San Ildefonso
terrace jar**
1860-1920
Clay and paint
H. 7½ in. (19.1 cm)
VILCEK COLLECTION
VF2016.01.05

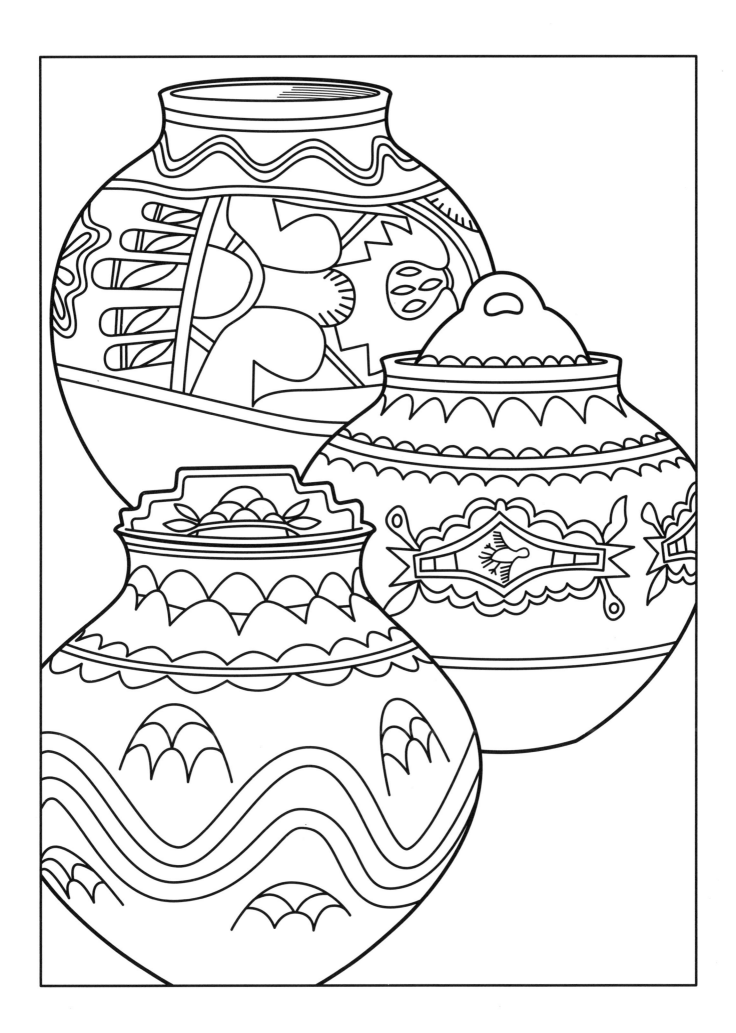

Zia storage jar
20th century
Clay and paint
H. 13½ in. (34.3 cm)

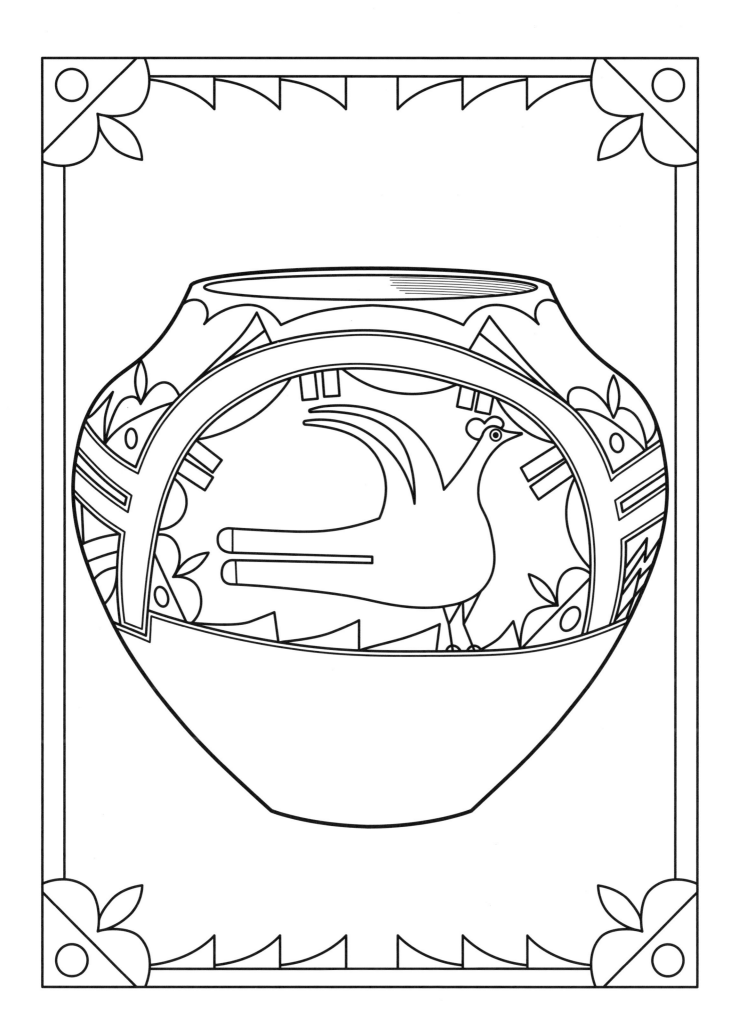

Pueblo girls learn to
balance pottery on their heads,
as this is how women transport
water from a river or
cistern back to the
family home.

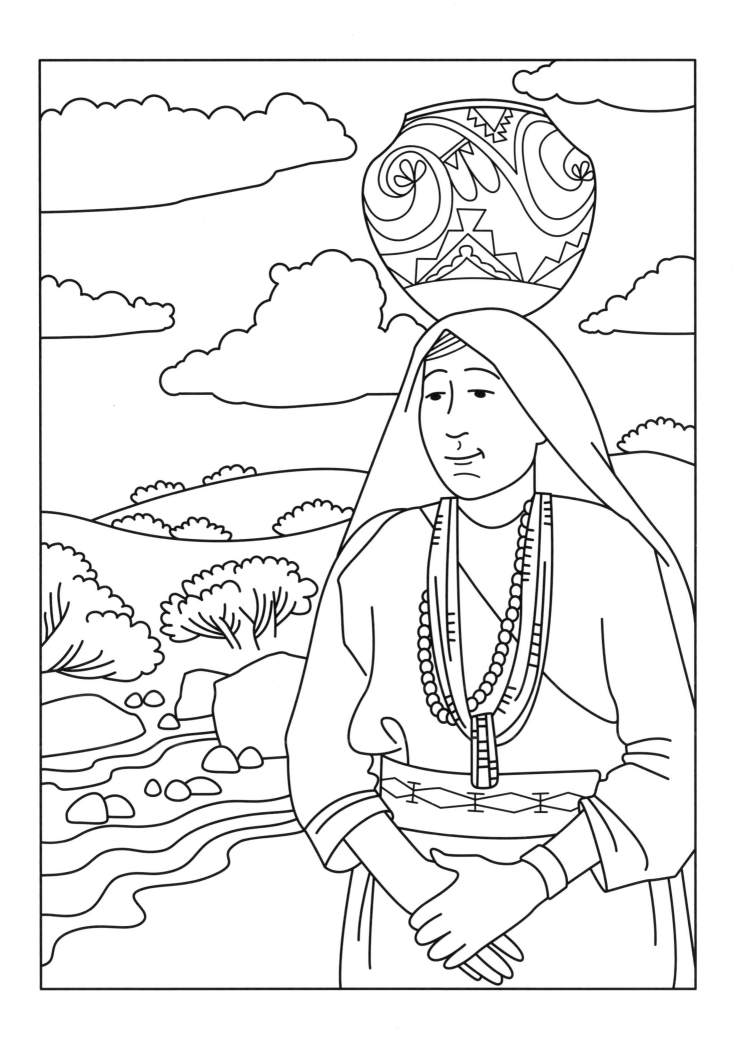

San Ildefonso
water jar
1860-1920
Clay and paint
H. 10½ in. (26.7 cm)
VILCEK COLLECTION
VF2016.01.07

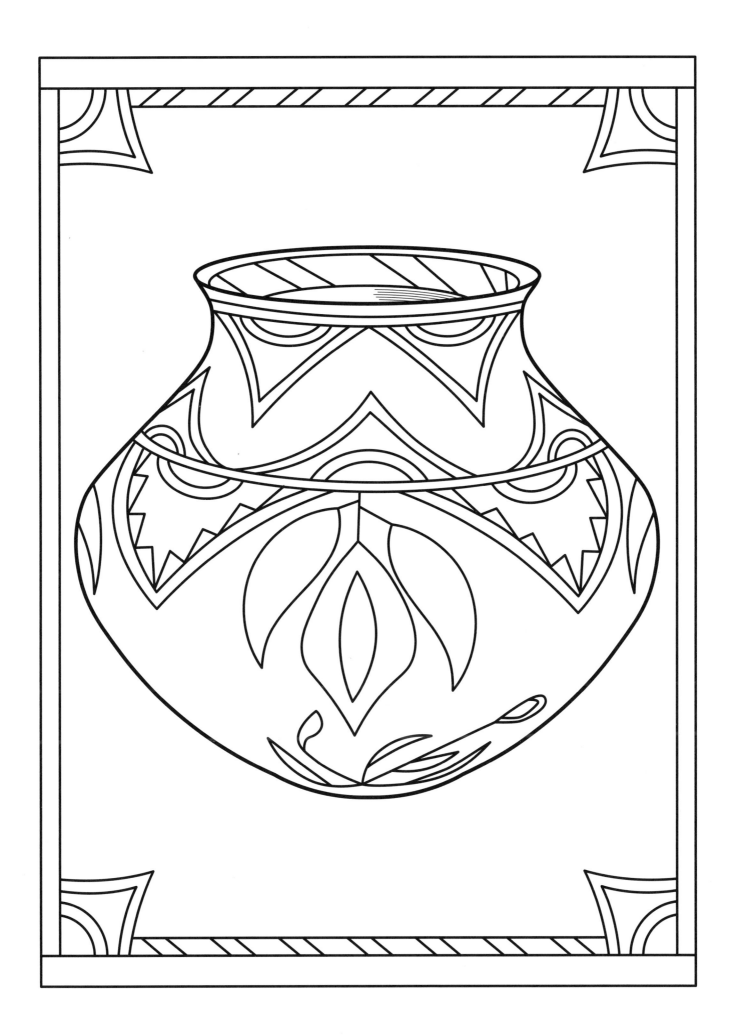

Zuni water jar
c. 1720
Clay and paint
H. 10 in. (25.4 cm)

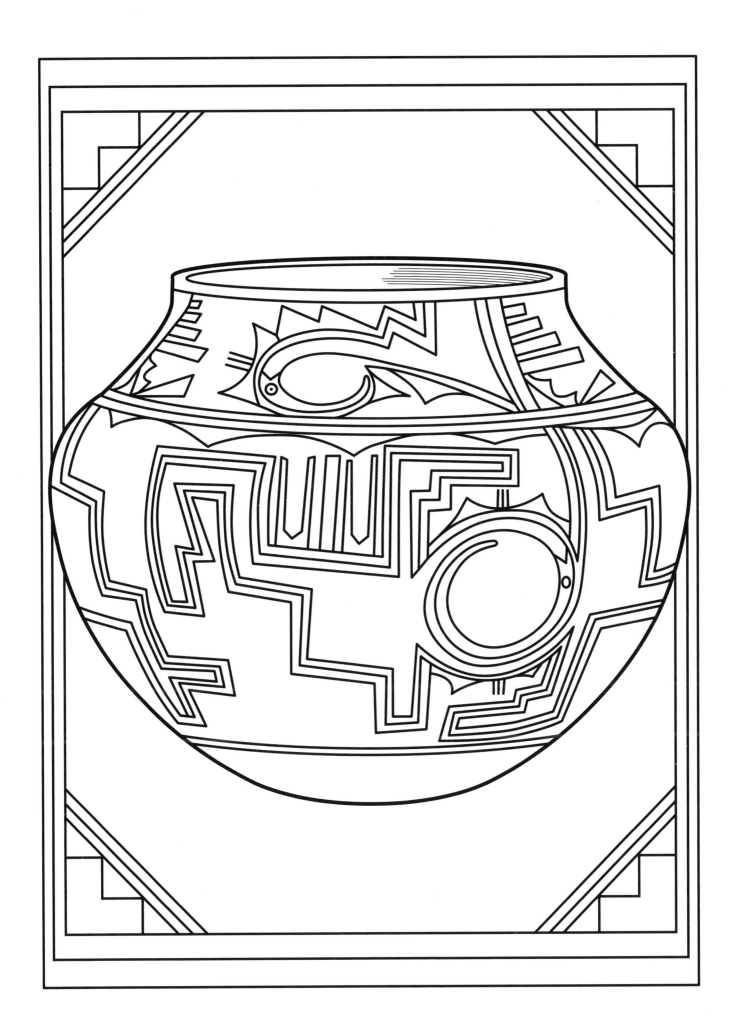

Santa Ana
water jar
c. 1870
Clay and paint
H. 11½ in. (29.2 cm)

Acoma dough bowl
with floral design
c. 1830-50
Clay and paint
H. 7 in. (17.8 cm)

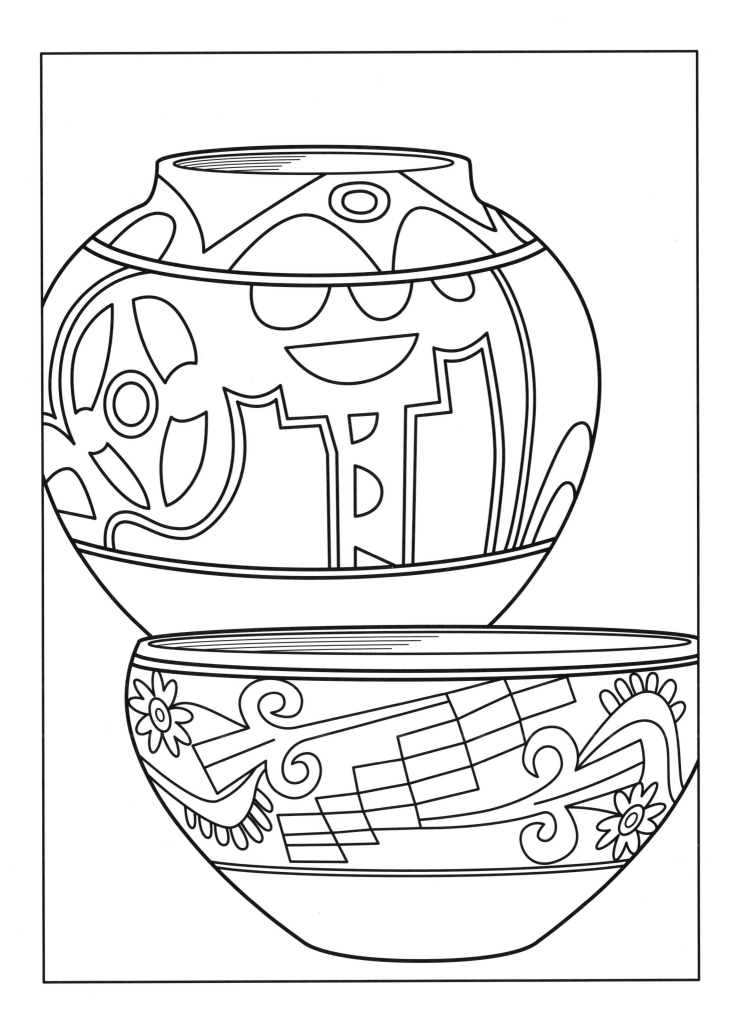

**Powhoge
storage jar**
*c.*1800
Clay and paint
H. 14½ in. (36.8 cm)

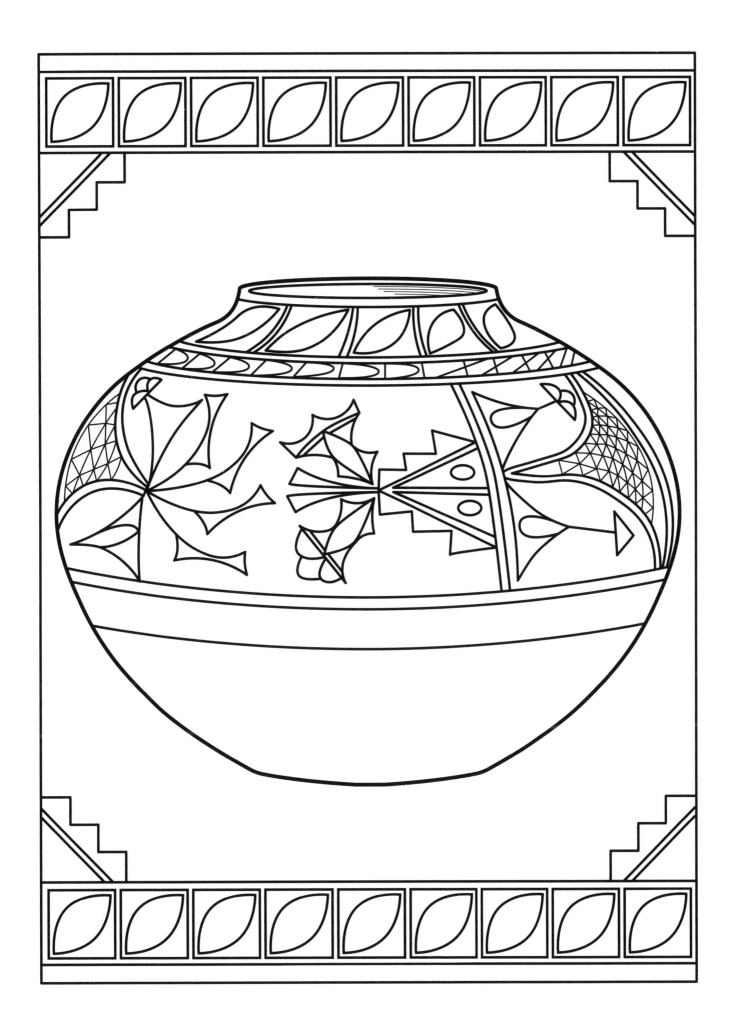

Two Pueblo women making and painting pottery
under the sun. Clay is gathered from a special place
near the Pueblo. Plants and minerals are also
collected and processed for use as paints.
Once finished, all pottery
is fired outdoors.

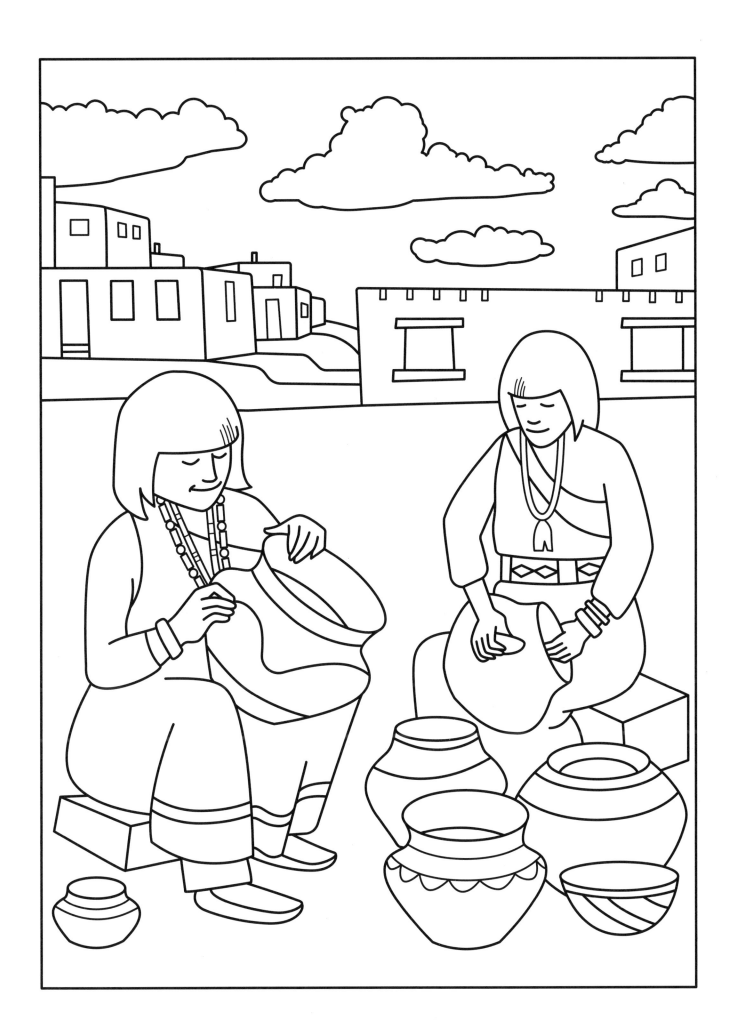

Crescenio Martinez
(1879-1918)
and Anna Martinez
(1885-1955)
San Ildefonso water jar
Early 20th century
Clay and paint
H. 8½ in. (21.6 cm)

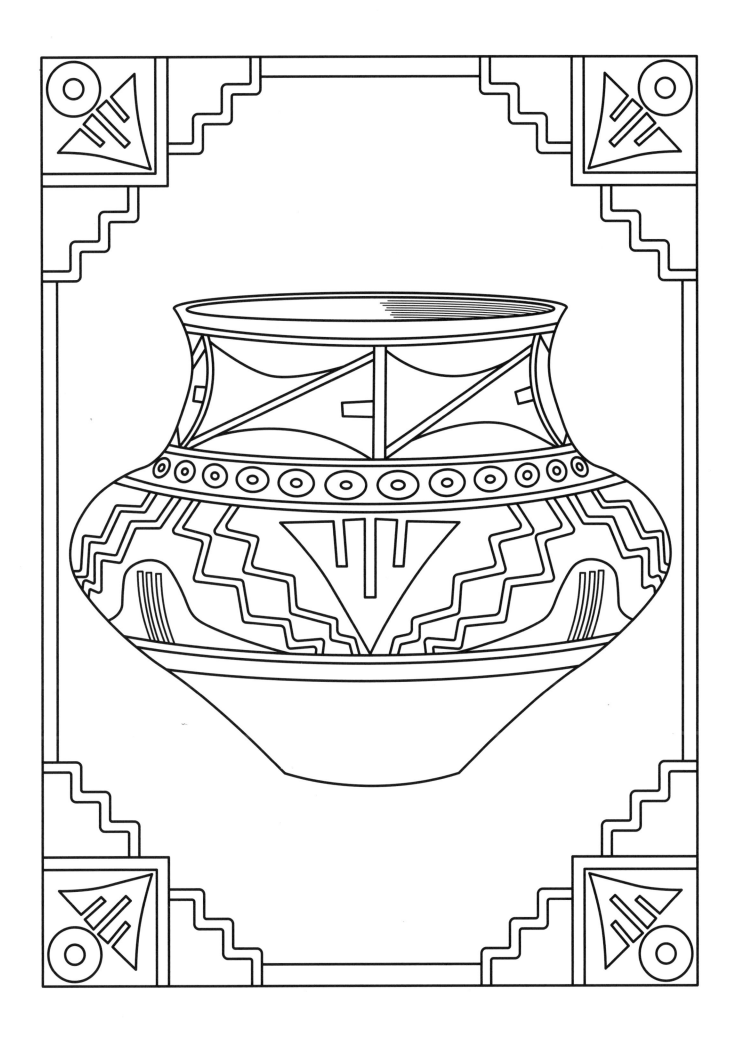

**Zuni water jar
with stylized bat design**
c. 1880
Clay and paint
H. 9 in. (22.9 cm)
VILCEK COLLECTION
VF2014.01.02

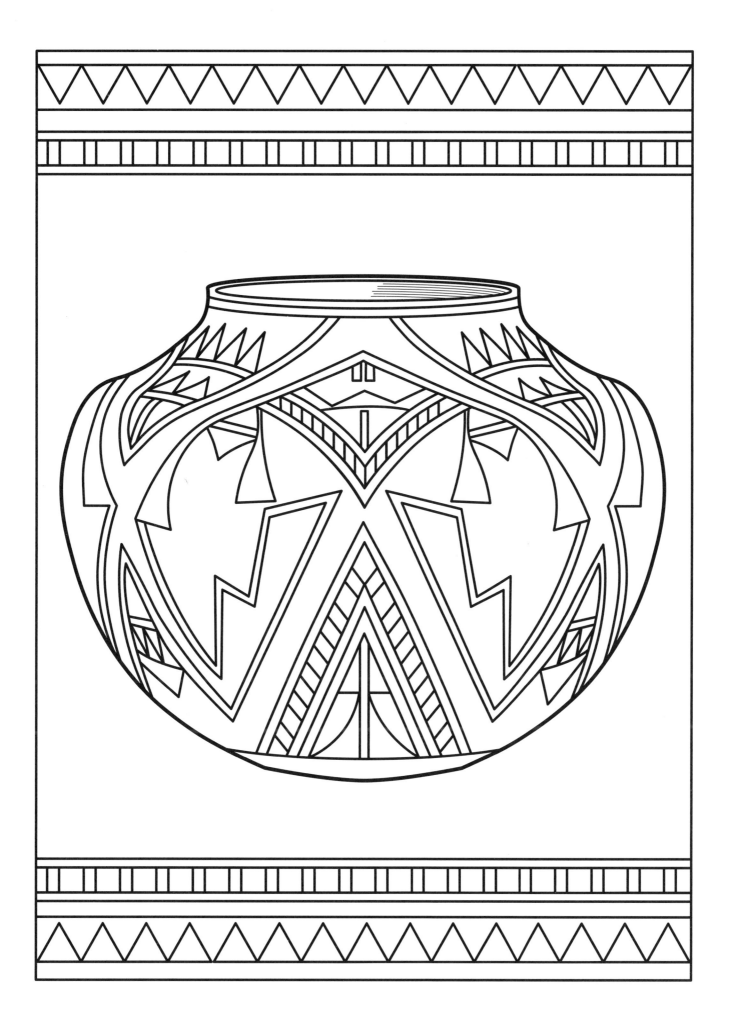

Hopi water jar
c. 1900
Clay and paint
H. 9 in. (22.9 cm)

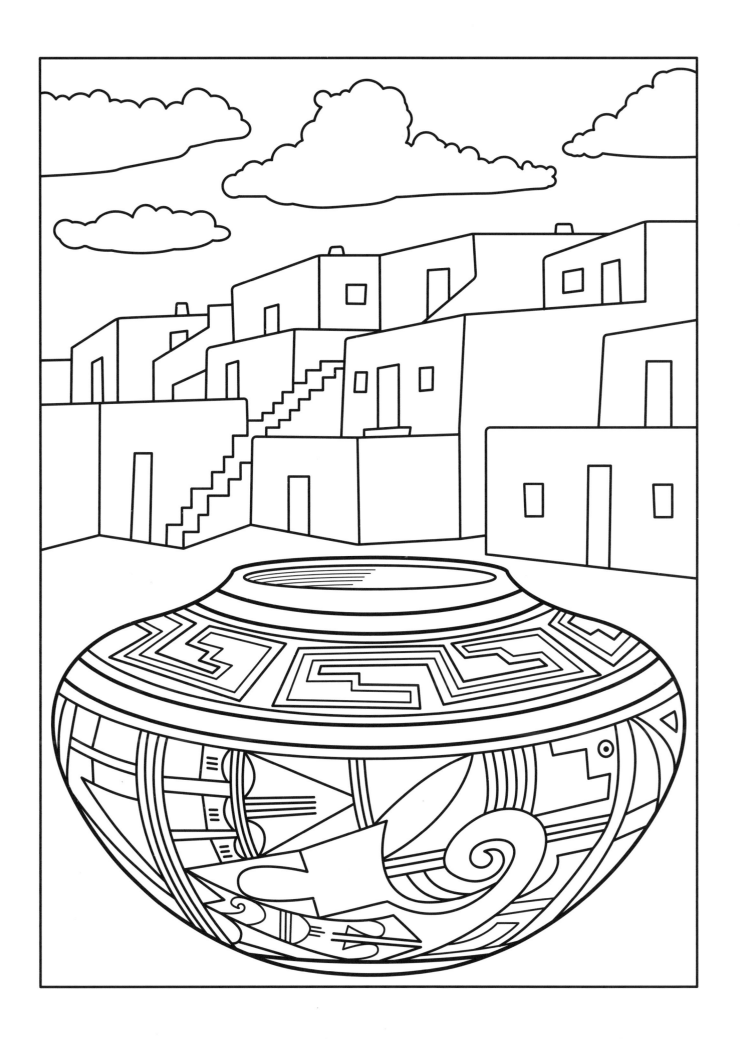

Acoma water jar
Early 20th century
Clay and paint
H. 7¼ in. (18.4 cm)

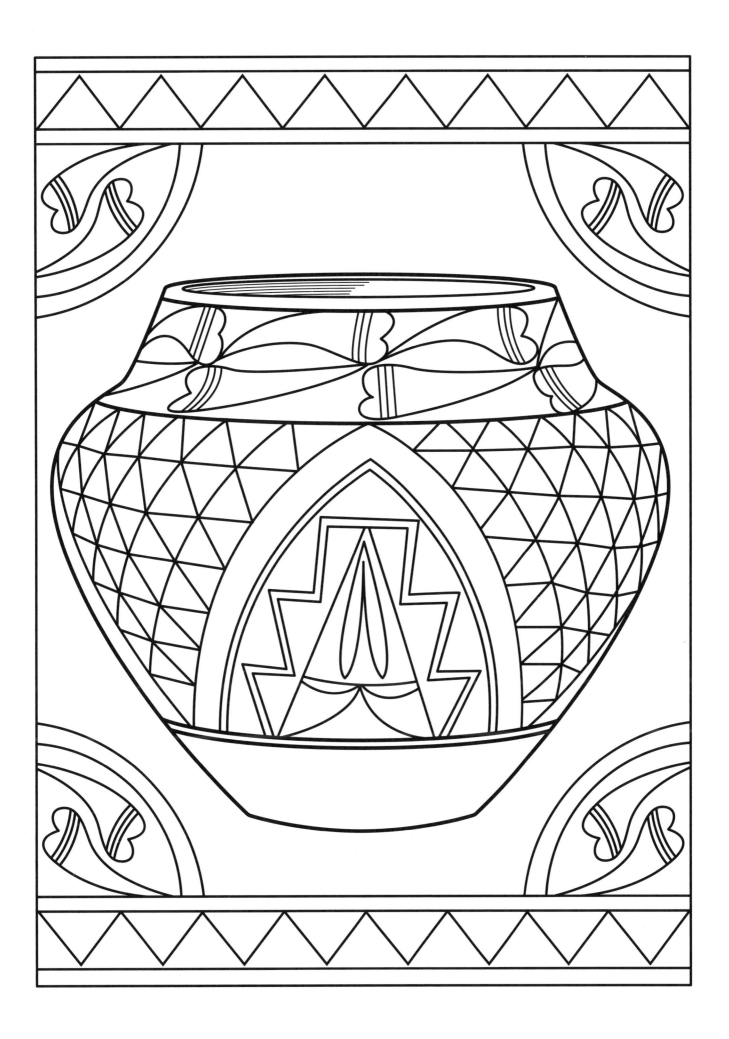

Acoma water jar
c. 1900
Clay and paint
H. 11 in. (27.9 cm)
VILCEK COLLECTION
VF2019.02.06

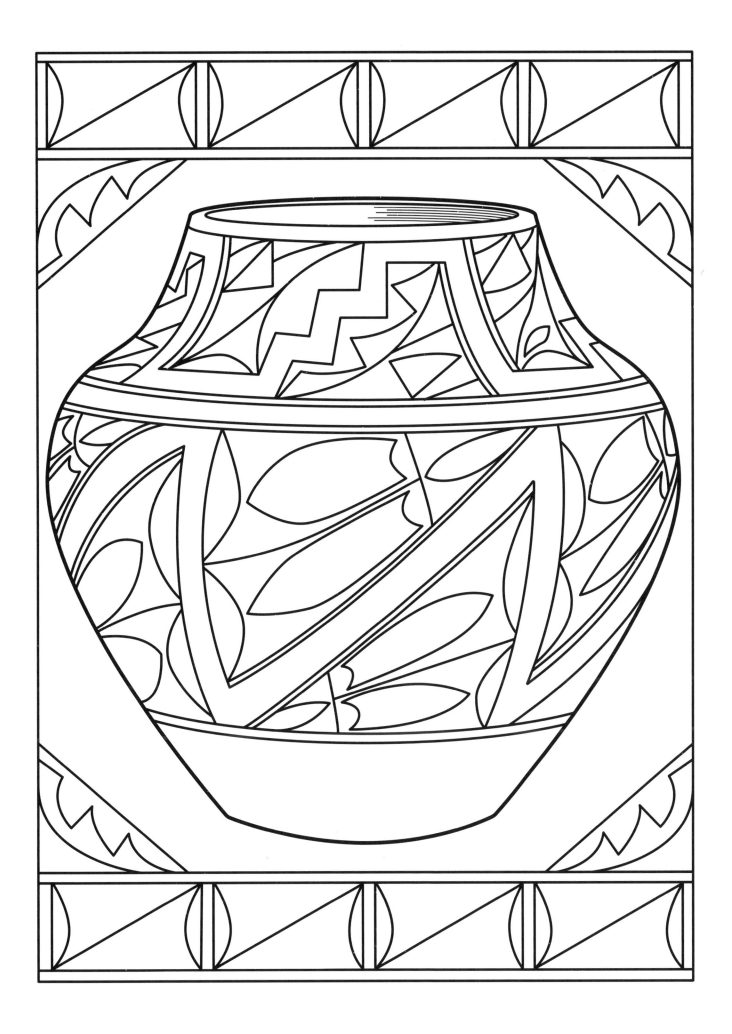

Acoma water jar
c. 1890
Clay and paint
H. 11 in. (27.9 cm)
VILCEK COLLECTION
VF2019.02.07

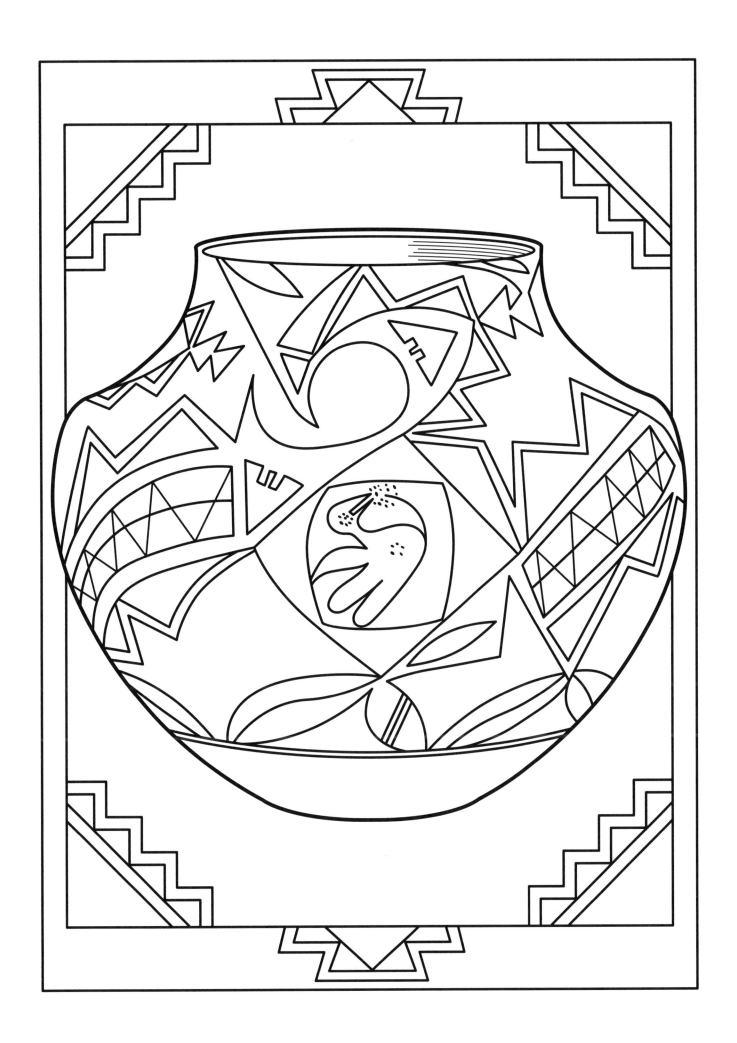

**Zuni water jar
with heartline deer design**
c. 1875
Clay and paint
H. 10⅞ in. (27.6 cm)
VILCEK COLLECTION
VF2017.05.01

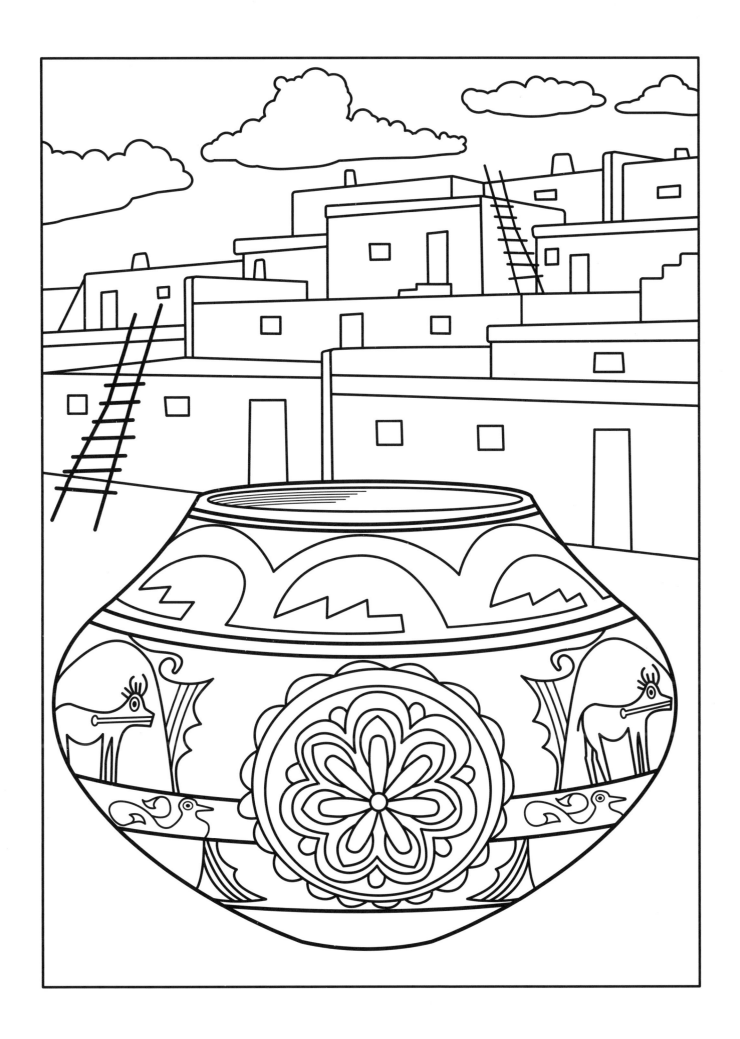

**Cochiti storage jar
with cloud, rain,
and bird design**
c. 1890–1900
Clay and paint
H. 18½ in. (47 cm)
VILCEK COLLECTION
VF2016.01.03

Powhoge water jar
c. 1780–1800
Clay and paint
H. 9½ in. (24.1 cm)
VILCEK COLLECTION
VF2018.02.01

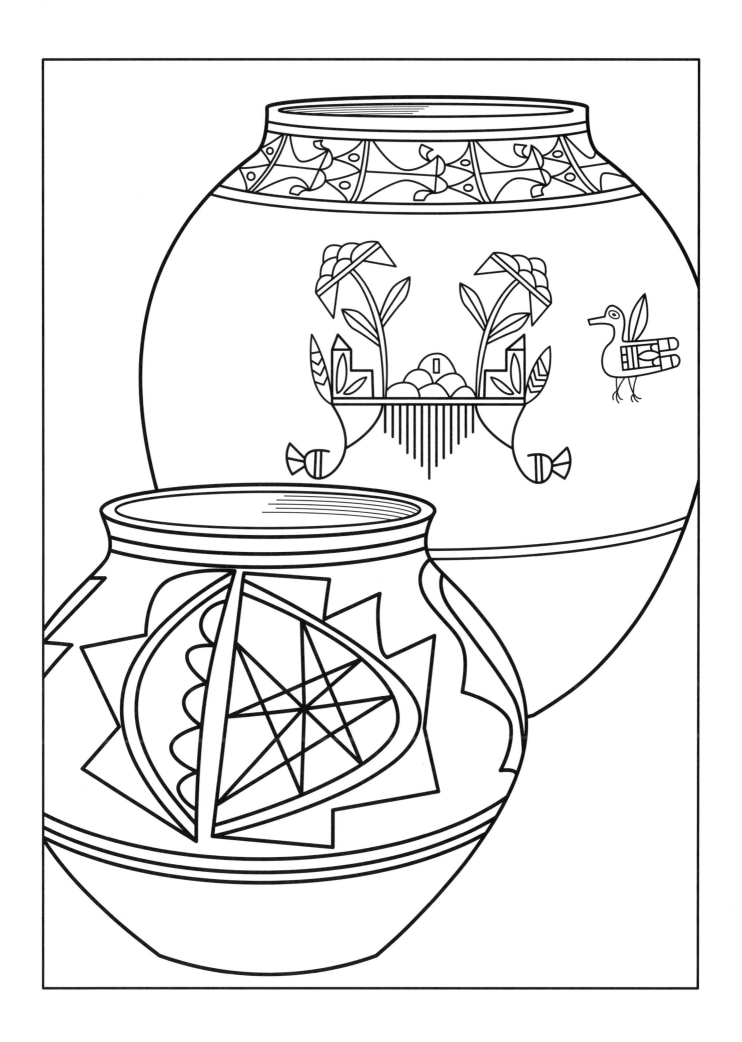

First published 2022 by Merrell
Publishers, London and New York

Merrell Publishers Limited
70 Cowcross Street
London EC1M 6EJ
merrellpublishers.com

in association with

Vilcek Foundation
21 East 70th Street
New York, NY 10021
vilcek.org

Text copyright © 2022 Vilcek Foundation

Illustrations copyright © 2022 Vilcek
Foundation, with the exception of
photograph of colored pencils on cover:
© iStock.com/worldofstock

Design and layout copyright © 2022
Merrell Publishers Limited

A catalogue record for this book is
available from the Library of Congress.

British Library Cataloguing in
Publication Data. A catalogue record
for this book is available from the
British Library.

ISBN 978-1-8589-4704-4

Produced by Merrell Publishers Limited

Printed and bound in China

Front cover: Acoma water jar, c. 1870;
see p. 13.
Back cover, left: Zia water jar, c. 1890;
see p. 5.
Back cover, right: Zia/Santa Ana
storage jar, c. 1885; see p. 27.

BRIAN VALLO is the Cultural Advisor,
Pueblo of Acoma.

PAULA KINSEL is an artist, graphic
designer, and art director.